52 Recipes from

"The Man Cave"

By "Gentleman Jim"

ISBN: 978-1-5272-1150-6

First Published: 2017

Design, artwork, content and photography J A Héroys

Having never really cooked for myself, except for the usual easy thing like beans on toast or oven ready chips, the thought of having to cook for myself day in day out was somewhat daunting. The good news is, it can be remarkably easy to produce good looking and tasty food without too much effort at all.

I have discovered that the key is really very simple. I have come up with the mnemonic NMT (pronounced Numpty!) which stands for Numbers, Mix, and Timing.

1. Numbers (have the right quantity and type of ingredients)
2. Mix (combine them in the right order)
3. Timing (cook them for the desired time and temperature)

If you follow the instructions on the following pages you too can produce some good food for yourself and indeed impress your guests with the flavours and presentation of your dishes.

All recipes can be dealt with by a Numpty (NMT)! Remember break it down to the basics. All you have to do is buy the ingredients, prepare them accordingly, adding them together and keep an eye on the cooking time and temperature. I have found that every recipe is designed for a Numpty! Just follow the instructions, after all a recipe is a set of instructions. Very quickly you will be confident of adding your own twists to them.

Remember it is not difficult – if I can do it you can as well.

Gentleman Jim

Contents

ngredients:
Salt, pepper, cumin seeds, fennel seeds, saffron, cinnamon, ginger, basil, coriander seeds, cumin, garam masala, bouquet garni, tumeric, mixed herbs, crushed chillies, sesame seeds.

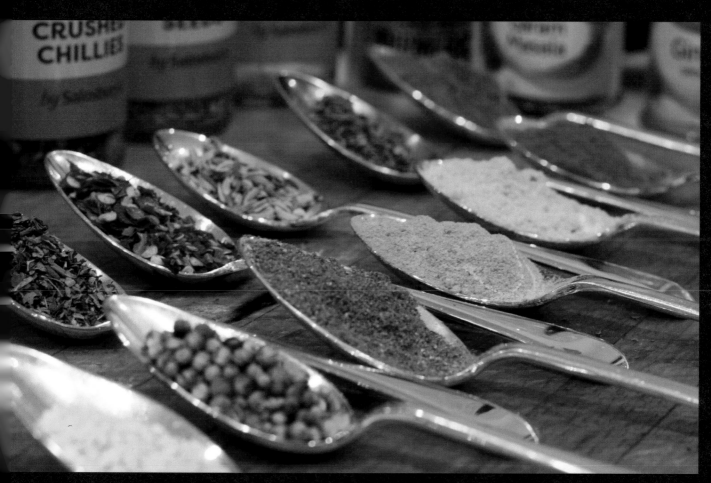

Other kitchen essentials: dark soy sauce, lights soy sauce, tamarind paste, heinz tomato ketchup (tommy K), vegetable cube, beef cube, rich beef stock pot, plain flour, '00' pasta flour, strong white flour, sugar, baking powder, yeast, pasta and spaghetti pasta, bread, eggs, milk, butter, garlic, onions, tomatoes, peppers, red currant jelly, mint sauce, english mustard, wholegrain mustard, horseradish, lemon, sunflower oil, extra virgin olive oil, white wine vinegar, balsamic vinegar, worcestershire sauce, tomato purée and passata.

Rome wasn't built in a day...... so here goes. My New Year's resolution - to be able to cook proficiently. Here is my first ever effort - spaghetti bolognese.

Ingredients:
1 tbsp olive oil, 2 onions, 500g passata, 2 garlic cloves, 500g beef mince, basil, 2 tbsp tomato purée, squirt of tommy K, 1 beef stock cube, 1 glass red wine, parmesan, 400g spaghetti.

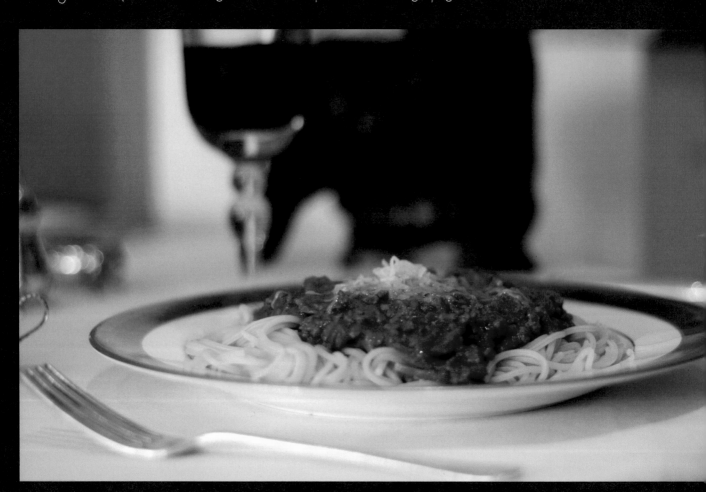

Put a frying pan on a medium heat and add the olive oil. Add the chopped onion, garlic and then fry, stirring often, unt softened. Increase the heat to medium-high, add the mince and cook stirring for 3-4 mins until the meat is browned all ove Add the passata, squirt of tomato ketchup, stock cube, tomato pureé, and wine. Bring to the boil, reduce to a gentle simme stirring occasionally, until you have a rich, thick sauce. When the bolognese is nearly finished cook the spaghetti followin pack instructions. Drain the spaghetti and add the bolognese sauce. Serve with grated parmesan and finely chopped bas for garnish. Serves 2.

After the Italian classic "Spaghetti Bolognese" I thought it was time for a French classic "Bouillabaisse".

Ingredients:
2 onions, 2 garlic cloves, 1 fennel bulb chopped, 8 tbsps olive oil, 500g tomatoes, skinned and chopped, bouquet garni, 1 strip of orange zest blanched, 600 ml vegetable stock, Pinch of saffron steeped in 2 tbsps boiling water, 2 dnz mussels, 375g white fish, skinned and cut into chunks, 375g oily fish and cut into chunks, salt, pepper, chopped parsley for garnish.

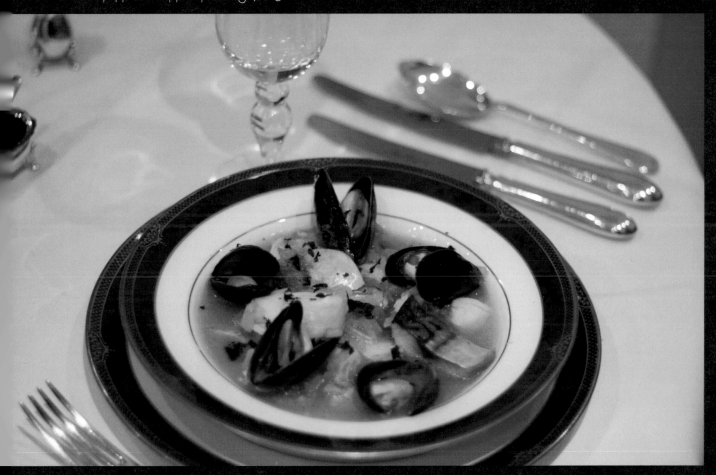

Fry the onions, garlic and fenel in 4 tablespoons of oil until soft. Add the tomatoes, bouquet garni, orange zest and boil for 10 mins.
Add 4 tablespoons of oil, the saffron along with its water, and the fish and bring to boil. Boil for 10 mins, season and garnish serve with bread rolls (see week 25). Serves 4.

chicken Jalrezi

Ingredients:
Tomato gravy - 2 tbsp oil, 4 chillies, chopped, 1 tsp cumin seeds, 4 garlic cloves, sliced, 1 tsp salt, 4 fres
tomatoes, chopped, ½ tsp turmeric, 8 chicken thighs. Jalfrezi fry - ½ tsp salt, 1 tbsp oil, 1 onion, 1 red peepe
1 green peeper cut into chunks, 1 tsp cumin seeds, 1 tomato chopped, 2 chillies chopped. 1 tsp garam masala
naan bread (in foreground)- 1 tsp yeast, 1 tsp sugar, 200g plain flour, 1 tsp black onion seeds, ½ tsp salt
½ tsp baking powder, 1 tbsp vegetable oil, 2 tbsp plain yoghurt, 2 tbsp milk. All washed down with a pint o
cobra!

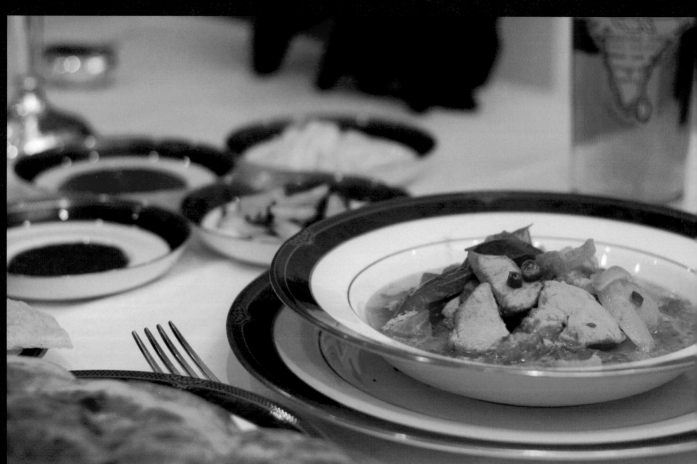

Heat the oil in the pan add cumin seeds, chilli and garlic, fry until lightly browned. Add the chopped tomatoes, salt and turmeric
cook until the tomatoes break down. Add the chicken, place lid on pan and cook for 15-20 mins on low heat. In a separate pa
heat some oil, add the cumin seeds, onions, peppers, tomato, and chilli and stir fry, stir in the garam masala. Once the chicke
is cooked add the sauce. Naan bread - Mix the yeast and sugar with a tablespoon of warm water. Leave for 5 minutes. Mi
the flour, onion seeds, salt and baking powder. When the yeast is frothy add it to the flour with the oil and yoghurt. Knead th
dough. If dry add some milk and continue to knead. Cover with cling film and leave for 1 hr. Divide the dough into four balls
roll each into a tear shape about 0.5cm thick. Place the naan onto a hot frying pan for a couple of seconds to brown on on
side. Place under a hot grill for 4 mins (seared side down), smear with butter. Serves 4.

t's the turn of the absolute classic (of travel snacks) one of my all time favourites - The Samosa.
Almost as good as those from the "duka" found alongside the dust roads of East Africa (although I struggled to replicate the dust and diesel fumes which clearly sets them apart from all others!).

Ingredients:

samosa: 500g wheat flour, 2 tspn ajwain seeds, 3 tspn oil, pinch of salt.

Filling: salt, pepper, vegetable oil, 400g potatoes, 250g cauliflower, 120g frozen peas, 1 onion, 2 cloves of garlic, 1 piece of fresh ginger, 2 green chilli, 2 tspn cumin seeds, ½ tspn fennel seeds, 1 tspn garam masala, 1 tspn ground coriander, ½ a lemon (juice), coriander.

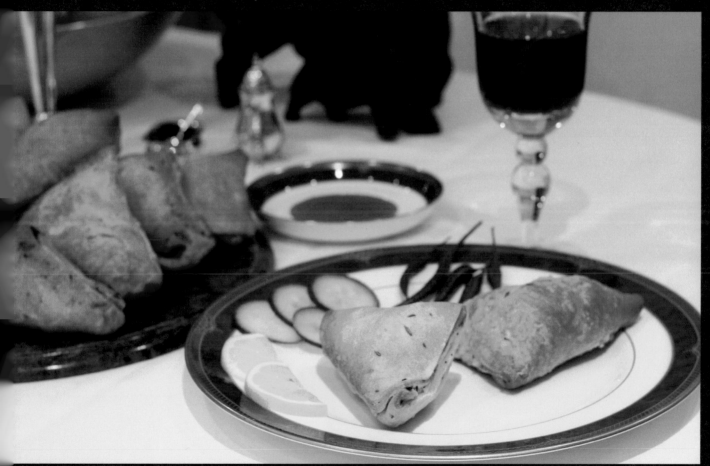

Mix the flour, pinch of salt, ajwain seeds and oil in a bowl. You will notice the mixture will turn crumbly after mixing. Now, add water in multiple small quantities and knead to firm dough. Cover with a wet cloth and leave to rest for 25 mins. Chop the potatoes and cauliflower into chunks. Add the potatoes to a pan of boiling water and cook for 10 mins and the cauliflower for 7 mins. Add the peas for the final minute. Chop the onion and garlic and finely grate the ginger and chilli. Heat some oil in a frying pan over a medium heat, add the cumin and onion. Fry for 8 mins, stir in the garlic, ginger and chilli. Bash the fennel seeds to a fine powder and add to the pan along with the garam masala and ground coriander. Stir the cooked veg into the pan and crush gently with a potato masher. Squeeze in the lemon juice and leave to cool. Divide the dough into 6 small portions and make round shaped balls from it. Take one dough ball and press it between your palms to flatten it a little. Put it over a rolling board and roll it out into a round shape approx 5 inch diameter. Cut each round in half, then brush the straight edges with a little water. Roll into a cone shape, bringing the straight edges together and pressing lightly to seal. Spoon in the filling, brush the exposed dough with water, then fold over and press to seal. Heat oil in a deep pan over medium heat. When the oil is hot, add 2-3 samosas, do not over crowd the oil to cook them evenly. Remove once golden brown. Serves 12 samosas.

I had a sous-chef with me today who insisted on cooking pizza, in fact it turned out that I became the sous chef!

Ingredients:
For the base - 300g strong bread flour, 1 tsp instant yeast, 1 tsp salt, 1 tbsp oil.
For the tomato sauce - 100ml passata or tomato purée, 1 garlic clove, crushed.
For this topping: grated cheddar cheese, green peppers, anchovy, olives, mushroom, onion and pepperoni.

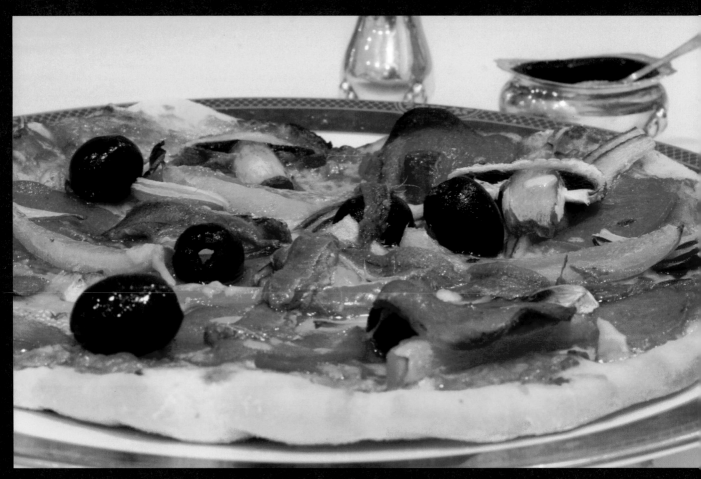

Put the flour into a bowl, stir in the yeast and salt. Pour in 200ml warm water and the olive oil and stir. Place onto a floured surface and knead for 5 mins, cover with a tea towel and leave for 5 mins. Make the sauce by adding the passata, and crushed garlic or just use tomato purée. Roll out the dough thinly. Add the tomato sauce and desired toppings of your choice and place in the oven at 200C for 10 mins. You won't believe how easy making a pizza base is and adding the topping isn't exactl difficult! Serves 4.

When it comes to hospitality, a Russian welcome can be hard to beat, normally accompanied with plenty of frozen vodka. The Blini (small, yeasted pancakes, traditionally made with buckwheat and often served in Russia as a welcoming snack for visitors).

Ingredients : 120g self-raising flour, 1 egg, olive oil, 120g semi-skimmed milk, chunk of butter.

Toppings, varied but included: crème fresh, smoked salmon, caviar, quails eggs, chives, cucumber, black pepper, dill, lemon, and horseradish.

All of course washed down with a shot of frozen Nemiroff original vodka.

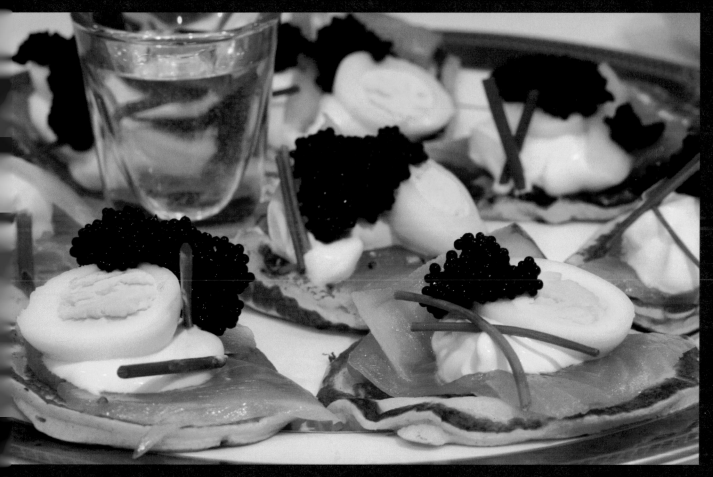

Place the flour and a pinch of salt in a mixing bowl. Make a well in the centre, crack in the egg and add 1 tablespoon of oil, then beat into the flour. Gradually whisk in the milk until you've got a smooth batter. Put a non-stick frying pan on a medium heat and add a small knob of butter. Once hot and the butter's melted, add a tablespoons of batter for each blini. Cook for 1 minute on each side, flipping over when they turn golden on the bottom and get little bubbles on top. Transfer the cooked blinis to a plate. Add toppings. Serves 4.

ravioli

Not the most photogenic food, but without doubt the best ravioli I have ever tasted.
Garlic mince Ravioli topped with tomato sauce and a sprinkling of parmesan.

Ingredients:

For the pasta - 500g '00' pasta flour, plus extra for dusting, 2 tsp salt, 5 eggs, 1 tbsp olive oil, For the filling
3 tbsp olive oil, 500g pork mince, 3 garlic cloves, 1 onion, 1 celery stalk, finely chopped, 2 eggs, 3 tbsp choppe
parsley, 3 tbsp parmesan, plus extra to garnish, 3 tbsp tomato sauce (see sauce), For the tomato sauce: 3 tbs
olive oil, 3 garlic cloves, 1 celery stalk, 1 onion, 700g passata. 2 tbsp chopped basil, 1 tsp dried oregano, 1 ts
sugar, pinch salt.

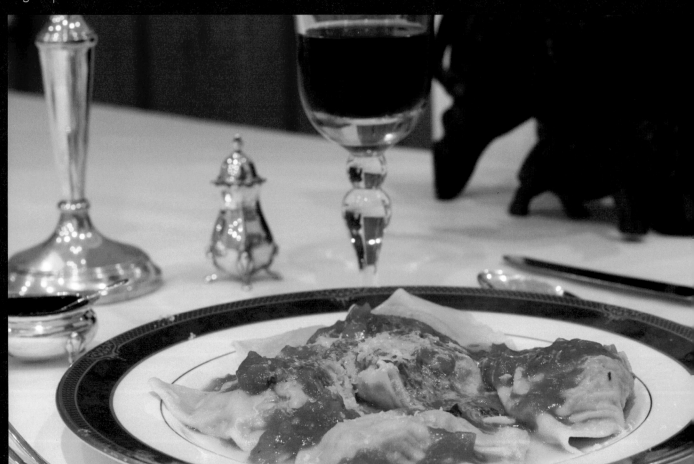

For the pasta, pile the flour into a bowl and make a well in the centre. Pour the salt, eggs and oil into the well. Mix the ingredients togethe
then work the mixture into a dough using your hands. Turn the pasta dough out onto a lightly floured work surface and knead for 15 mir
until it is smooth and glossy. Roll the dough into a ball, wrap it in cling film and set aside to rest for 30 mins. Meanwhile, for the filling
heat the oil in a saucepan over a medium heat. Add the pork mince, garlic, onion and celery and fry gently for 15 mins. For the toma
sauce, heat the oil in a separate frying pan over a medium heat. Add the garlic, celery and onion and fry for 8 mins. Add the passata an
300ml water, stir the mixture well and bring to the boil. Simmer gently for 30 mins, then stir in the basil, oregano, sugar and salt. Allow t
cool. Beat in the eggs, parsley, parmesan and 3 tablespoons of the tomato sauce. To make the ravioli, cut the dough into satsuma-size
pieces. Dust the rollers of a pasta machine with flour and feed it through. Fill the pasta with filling. Boil for 3-4 minutes, they are cooke
when they float to the surface of the water. Serve the ravioli topped with the warm tomato sauce and a sprinkling of parmesan. Serves

Bread (dairy free/vegan vegetarian)

Ingredients: 500g strong bread flour, 300 ml warm water, 20g dried yeast, 1 tbsp sugar, 1 tbsp salt, flour for dusting, mixed, kneaded, first prove, second prove, baked then cooled, sliced and toasted, buttered and cut. 2 eggs, salt and pepper.

Put the flour into a large bowl, pour half the water then add the yeast, sugar and salt and stir. Continue to mix until you get a stodgy, porridgey consistency then add the remaining water. Continue mixing, making the mix less sticky. Push, fold and roll the dough around for 5 mins until you have a silky and elastic dough. Ball shape the dough and flour the top and cover with cling film, and allow it to prove for 30 mins. Once the dough has doubled in size, knock the air out for 30 seconds by bashing it and leave it to prove for a second time for 50 mins. Preheat the oven to 180°C. Shape and place your bread dough on a flour dusted baking tray. Bake for 30 mins or until cooked and golden brown. You can tell if it's cooked by tapping the bottom – if it sounds hollow it's done. Boil the 2 eggs (as Grandpa would say "What's the use of one") for 4 1/2 mins.

pad thai Week 10

Having been to Wagamama's recently I thought to myself.....I can do that.
Prawn pad thai
Ingredients:
1 leek, 1 red onion, 1 egg, 2 handfuls of beansprouts, 1 tsp of ginger, 2 garlic clove, splash of vegetable oil
amai sauce (2 tbsp malt vinegar, 6 tbsp sugar, 2 tbsp light soy sauce, 2 tbsp dark soy sauce, 2 pinches o
salt, 2 tbsp tommy K, 4 tsp tamarind paste), 2 balls of rice noodles, 20 prawns and 2 red chillies. To garnish
1 tbspn of crushed peanuts, pinch of dried chilli flakes, ¼ lime, and of course chop sticks (hand chosen i
China by my dear friend Katy).

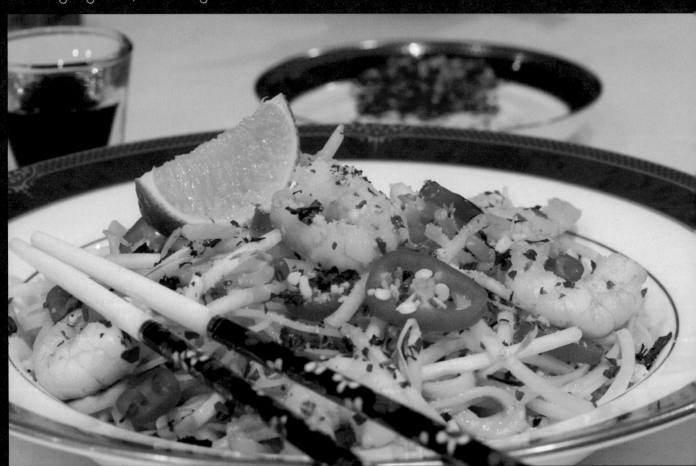

Cook rice noodles in pan of boiling water (follow packet instructions). Chop the leek, onion, chillies,grated ginger and grate
garlic and place all in a hot frying pan with a splash of oil, toss, add whisked egg, prawns, and drained cooked noodles, tossin
ingredients quickly, add amai sauce and beansprouts. Place on a plate, garnishing with crushed peanuts, chilli flakes an
lime. Serves 2.

An East African speciality

Nyama Choma

Ingredients:
Traditionally made with Goat meat, I used beef.

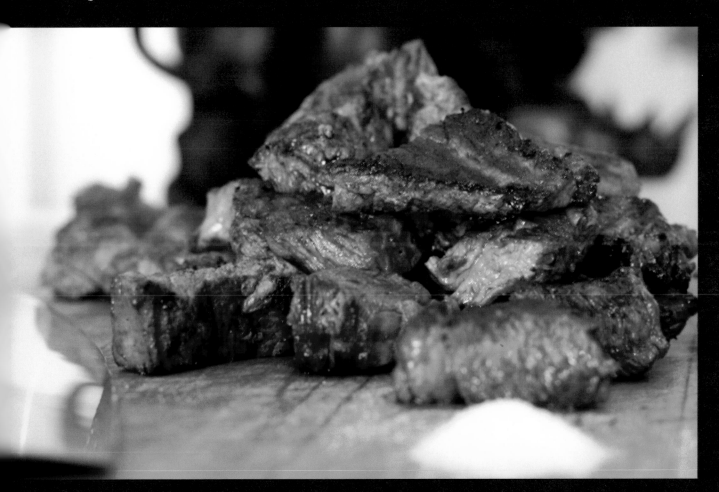

Place steak on grill over hot wood embers or griddle pan. Once cooked cut into chunks add a pile of salt to one side – Done!
You could add chilli, oil and tomatoes to a bowl and use as a dipping sauce.

Shrove Tuesday

Ingredients:
100g plain flour, 2 eggs, 300ml milk, 1 tbsp vegetable oil, plus a little extra for frying, lemon, salt, sugar

NEVER buy a pre mix, always make your own, dead easy and delicious. Mix the flour, eggs, milk, oil and a pinch of salt in
bowl and whisk to a smooth batter. Wipe the frying pan with some oiled kitchen paper and add a thin layer of the batter mi
on a medium heat. Cook your pancakes for 1 min on each side until golden. After several attempts you will be able to toss th
pancakes over like a professional! Serve with lemon juice and sugar. Serves 4.

This week it is back to what we all used to enjoy – simple, but still a favourite, good old nursery food.

Ingredients: No tinkering - made as it should be - frozen birds eye fish fingers, frozen chips, heinz baked beans, salt, pepper, tommy K.

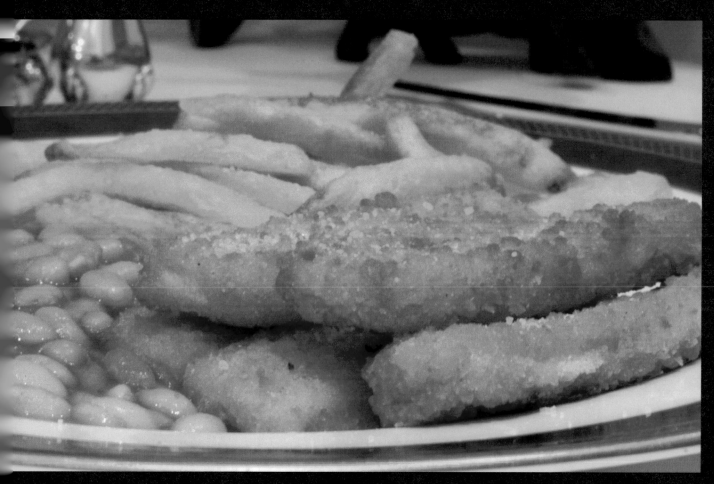

Follow instructions on the packets - easy!

Ingredients:
1 chicken, cut into joints, 225g small mushrooms, salt, pepper, 725ml red wine, 25g butter, 1 tbsp butter,
tbsp plain flour, 1 tbsp oil, 225g bacon, 16 button onions, 2 cloves garlic, 2 sprigs fresh thyme, 2 bay leaves
parsley.

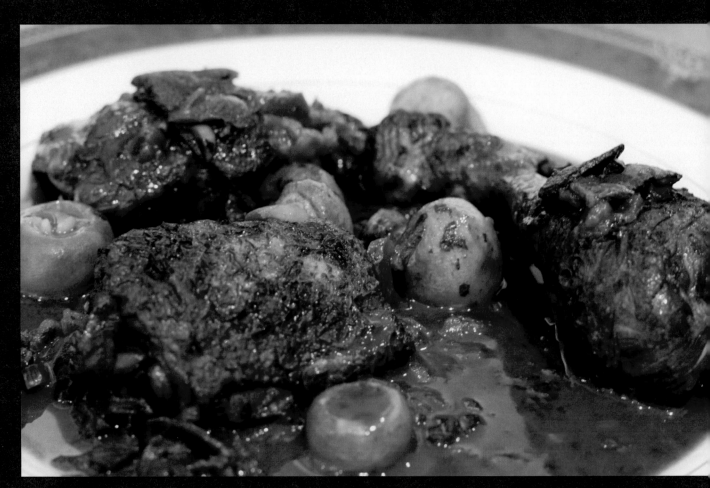

Melt the butter and oil in a frying pan, and fry the chicken joints, skin side down, until they are golden. Remove the joints from
the pan and place them in a cooking pot. Cut and cook the bacon and onions in the frying pan until lightly browned, add them
to the chicken, Add the garlic and thyme to the chicken, season with salt and pepper and a couple of bay leaves. Pour in the
wine, put a lid on the pot and simmer gently for 50 mins or until the chicken is tender. During the last 15 mins of the cooking
add the mushrooms. Remove the chicken, bacon, onions and mushrooms and keep warm. Bring the liquid to a fast boil and
reduce it by about one third. Add the butter and flour to the liquid. Bring it to the boil, stirring until the sauce has thickened
then serve the chicken with the sauce. Optional add parsley to garnish. Serves 4.

ingredients:

400g mushrooms, chopped very small, salt, pepper, olive oil, 750g piece of prime beef fillet, 2tbsp english mustard, 8 slices of parma ham, 500g ready-made puff pastry, 2 egg yolks, beaten.

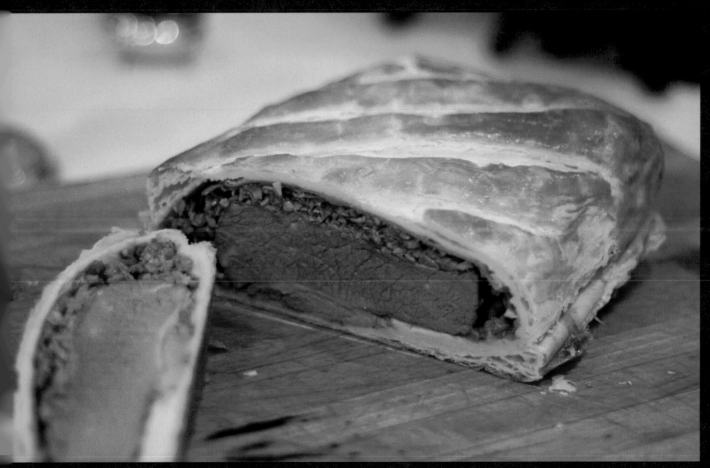

Put the mushrooms into a pan and cook over a high heat for about 10 mins, cooking out the moisture from the mushrooms. Spread out on a plate to cool. Place the beef and sear in the hot pan for 30 secs only on all sides. Remove the beef from the pan and leave to cool, then brush all over with mustard. Cover the parma ham slices with the mushrooms, then place the beef fillet in the middle. Neatly roll the parma ham and mushrooms around the beef to form a tight barrel shape. Roll out the puff pastry and place the beef in the centre and cover the beef and place on a baking tray. Brush over all the pastry with egg wash. Lightly score the pastry and glaze again with beaten egg yolk. Bake for 20 minutes, oven 200C, then lower the oven setting to 180C and cook for another 15 mins. Allow to rest for 10 mins before slicing and serving The beef should still be pink in the centre when you serve it. Serves 6.

Ingredients:
Crème fraîche, horseradish, smoked salmon, prawns, caviar, small leaf salad.
For the dressing: 1 lime (juice), 1 tsp clear honey, ½ tsp finely grated fresh ginger, 2 tbsp olive oil, pepper.

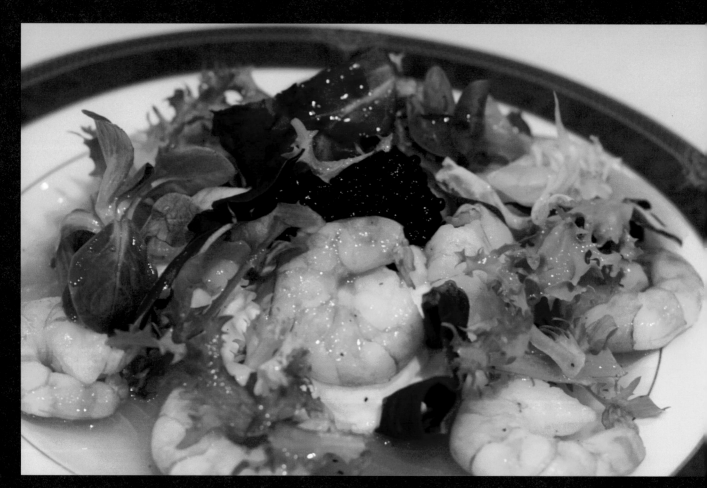

Lay the smoked salmon and prawns, then top with a dollop of crème fraîche, a dollop of horseradish, caviar, salt and peppe
Top with the salad and add dressing.

ngredients:
Add any cheese you like!

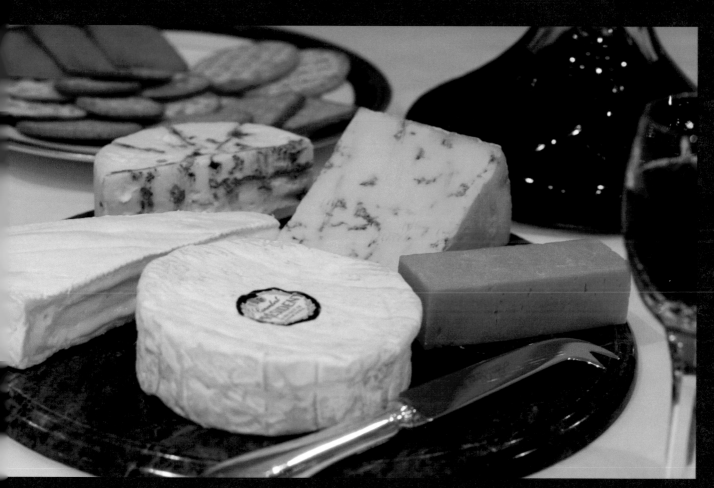

Buy the cheese and biscuits and unwrap - job done, easy! Washed down with a glass of port or madeira.

Ingredients:
Gin, Tonic water, Ice and lemon.

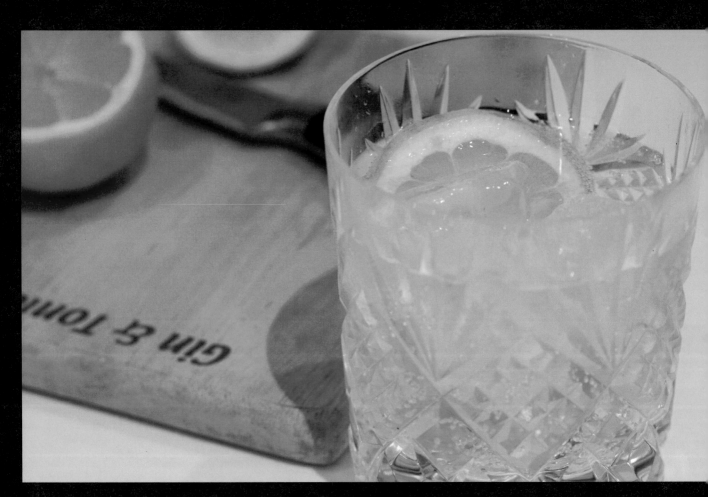

There are gin and tonics and there are gin and tonics. This is a gin and tonic!
Important to follow these steps in order - pour a double measure of Gordon's gin into the glass, add tonic water, ice and lemo
then pour slowly over the top a single measure of gin - just like Grandpa made them - perfect!

ngredients:
4 lamb chops
peas and chips, red current jelly, mint sauce, salt, pepper.

Grill the lamb chops, cook the frozen chips in the oven, boil some peas - easy! Add salt and pepper and either or both red current jelly and mint sauce. Serves 1.

Ingredients:
Plums, apples, bananas, tangerines, pineapple, pears.

Don't forget to keep a good selection of fresh fruit in the bowl.

4pm Afternoon Tea and Toast

ngredients:
Bread, butter and a topping of your choice to go with your afternoon cup of tea.

Afternoon tea, often under rated, best enjoyed in front of the television.

Ingredients:
2 fried eggs, 3 rashes of bacon, 3 sausages, 1 tomato, 2 black puddings, 1 piece of fried bread, baked beans,
mushrooms, salt, pepper, mustard, tommy K, orange juice, mug of tea.

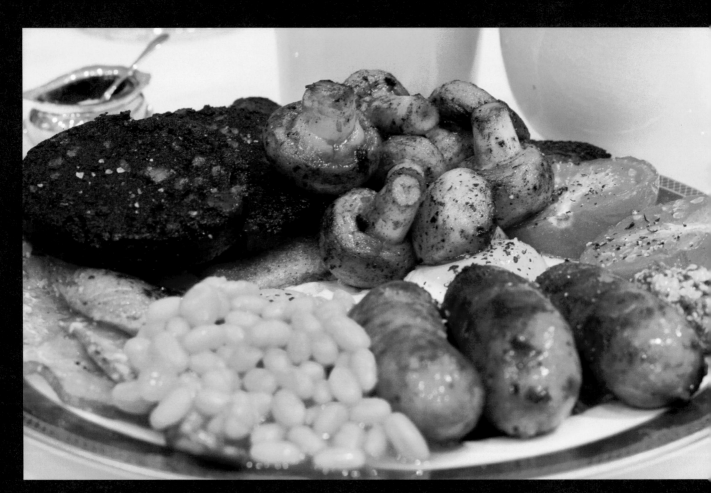

Fry or grill the bacon, sausages and tomatoes. Fry the mushrooms, black pudding, eggs and bread, season with salt, pepper,
tommy k, mustard etc. Accompanied by a glass of orange juice and a mug of tea. Guaranteed to set you up for the day.
Serves 1.

A popular filling snack with British troops since World War I, often accompanied by a mug of "gunfire".

Ingredients:
1 fried egg, 2 pieces of white buttered bread, tommy K, salt, pepper.

A sandwich of a runny fried egg between two thick slices of white bread. The British squaddie has christened this snack the "Egg banjo" due to the fact that after the first bite, the yolk has a tendency to explode and drips onto the shirt, causing you to whisk off the drops with the fingers from the free hand, with the sandwich raised in the other, giving the impression of strumming a banjo!

Ingredients:
6 eggs, 350g self-raising flour, 350g sugar, 350g butter, 3 tsp baking powder, 80g cocoa powder, water.
For the icing:
option 1: 200g plain chocolate, 200ml double cream.
option 2: 200g plain chocolate, 100g butter, 2 eggs, 350g icing sugar.

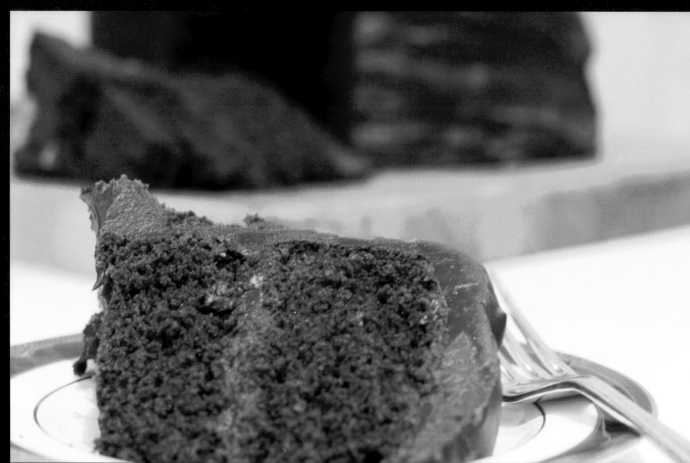

Preheat the oven to 180C. Mix the eggs, flour, sugar, butter and baking powder together. Mix together the cocoa and 10 tbs
of boiling water and then add to the cake mixture. Add the cake mixture to 2 8 inch greased cake tins and bake for 25 mins (t
check the cakes are cooked, stick a skewer into the middle of one and leave it for 5 seconds. If it comes out clean, the cake i
ready). Leave to cool and remove from the tins placing the cake on a wire shelf. To make the icing: Option 1 - Add the crear
and chocolate and melt over a pan of hot water over a low heat, once melted leave to cool for 1 hr. Option 2 - Add the butte
and chocolate and melt over a pan of hot water over a low heat, once melted take off the heat and stir in the eggs. Add th
icing sugar and beat until smooth and cold, use immediately. Cover both tops of the cake with the icing and place one on to
of the other (place the better looking icing cake on the top!). Serves 8.

Tomato soup and a bread roll

Ingredients:
1 tin heinz tomato soup, 500g of strong white flour, 1 tbsp of sugar, 1 ½ tsps of salt, 2 tsps of dried yeast, 1 glass of lukewarm water, pepper.

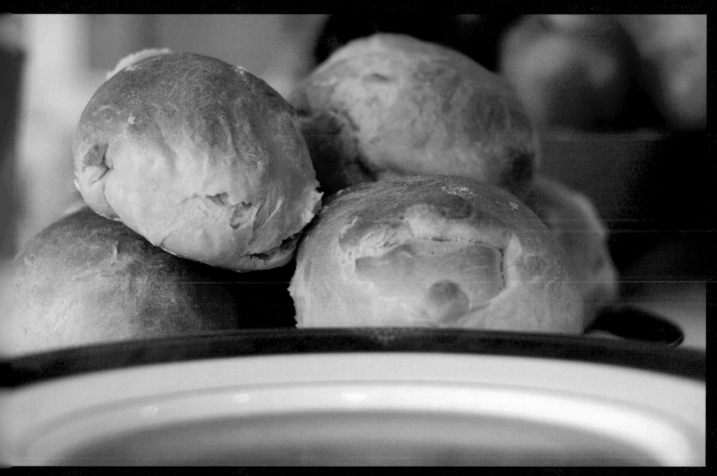

Place the flour and salt into a large mixing bowl, add the sugar and yeast to the water and allow to stand for 5 mins. Add the water mixture to the flour and mix well. Knead on a lightly floured surface until the dough is soft and silky. Place in a large bowl and cover with a damp tea towel for 1 hour. Then knead for 2 mins. Shape into rolls. Place on a floured baking tray, cover with the damp tea towel for 30 mins. Brush the rolls with salted water. Bake for 25mins at 200C. Warm up the tomato soup in a saucepan and serve in a bowl with plenty of black pepper. Serves 8 rolls.

Ingredients:
2 bananas, 1 tin of custard.

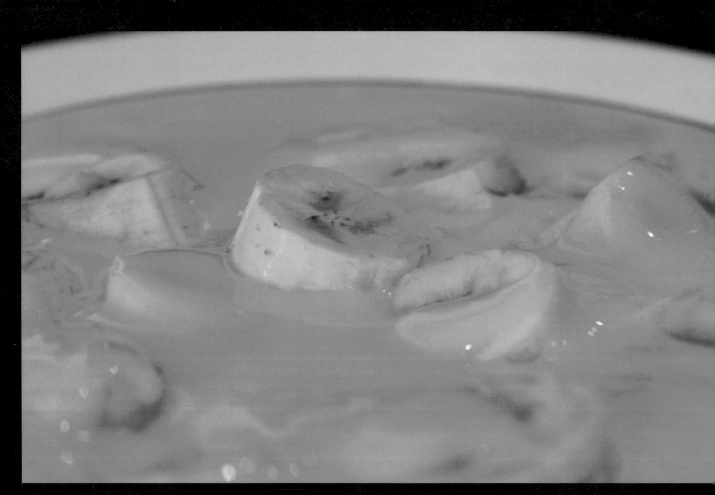

Back to nursery food. Why make custard when it is so good in a tin. Just warm up the custard chop up a banana over th
top - hey presto, job done. Serves 2.

ngredients:
1 lobster, 1 large steak, lemon, salt, pepper.

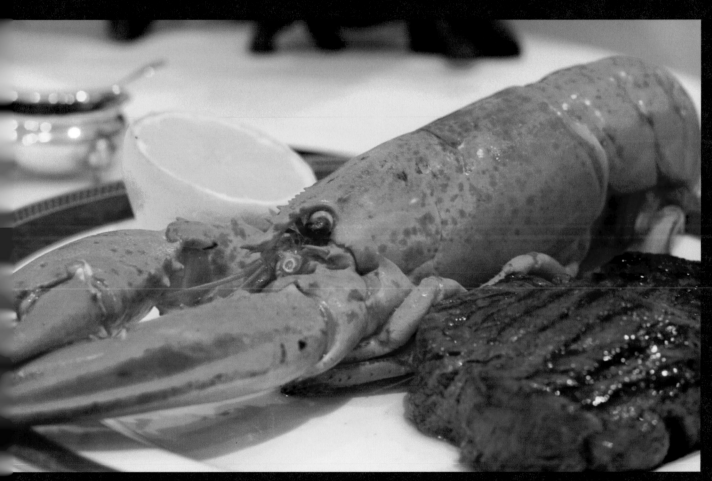

Unlikely you will have a live lobster in the Man Cave! So to cook the lobster you have bought follow the instructions - usually boil in some water or grill, personally I prefer mine without any "thermidore" sauce. For the steak, place on griddle pan and cook for a few minutes before turning over for a few minutes more (rare). Alternatively cook in a pan with a little butter, or grill, or even place on a tray in the oven. Remember everyone likes their steak cooked differently, so obvious as it may sound, ensure the "well done" ones go on first and the "rare" ones on last to ensure everyone is served at the same time. Serves 1.

Ingredients:
1 Craster kipper, buttered toast, tea, and orange/apple juice.

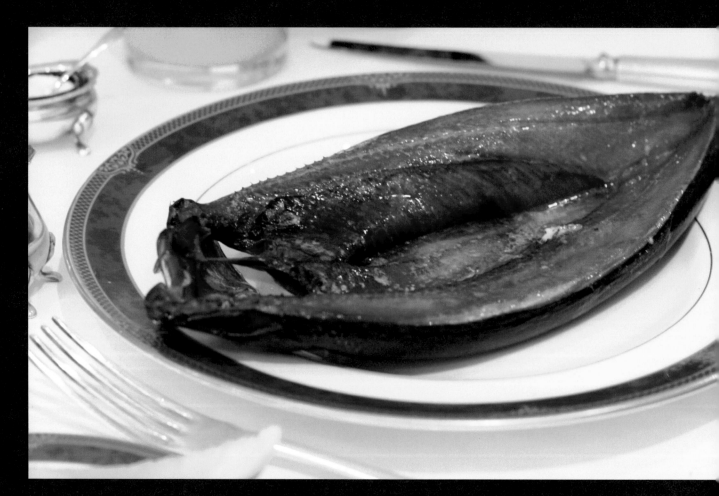

Either place under the grill or fill a large pan with boiling water, and simply place the kipper in head first with the tail just above the surface of the water. Leave for 6 mins and your kipper will be cooked to perfection. Smear with melted butter and serve with toast, tea and a glass of juice. Craster kippers are the best although the boil in the bag ones are easier to get hold of and still taste good. Serves 1.

No Cooking in The Man Cave!

The Doner Kebab

Every chef is entitled to a day off!

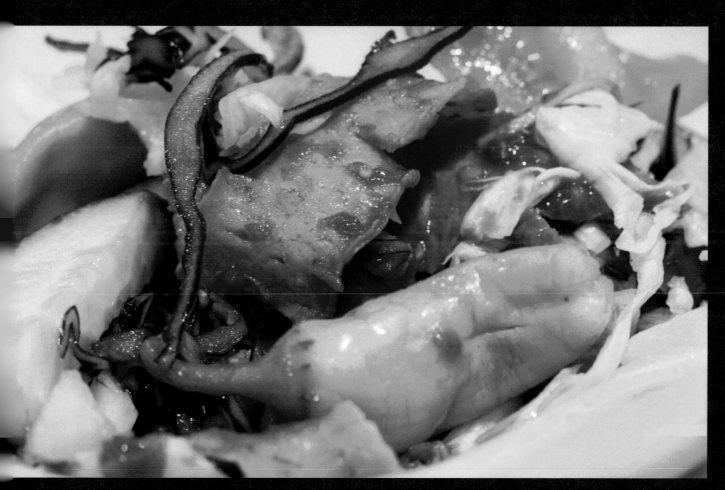

Go to your local kebab shop/van – they'll do it for you!

The 1970's classic

Ingredients:
Shelled prawns, (keep 4 back for garnish), lettuce, tommy K, mayonnaise, pepper, lemon, chives.

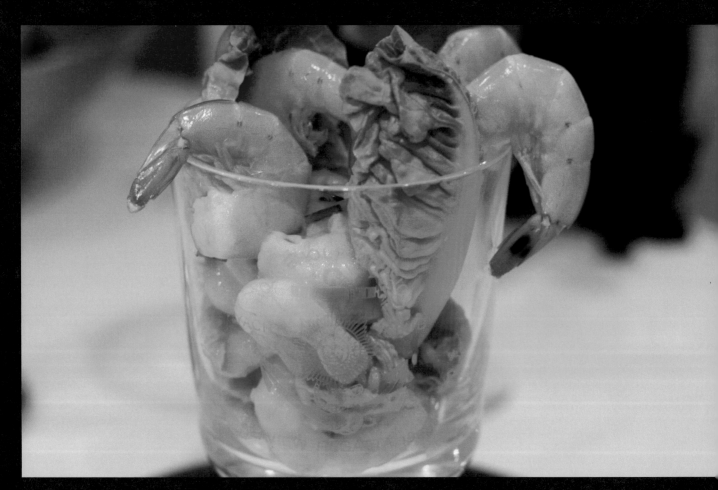

So many variations on this with or without horseradish, worcestershire sauce, tabasco, mary rose sauce etc. etc. This one is simple and delicious. Mix 50/50 tomato ketchup and mayonnaise for the sauce, add prawns, lemon juice and pepper. Add to glass serving dish along with lettuce and 4 prawns with chives to garnish. Serves 1.

Ingredients:
A dozen quails eggs, celery salt.

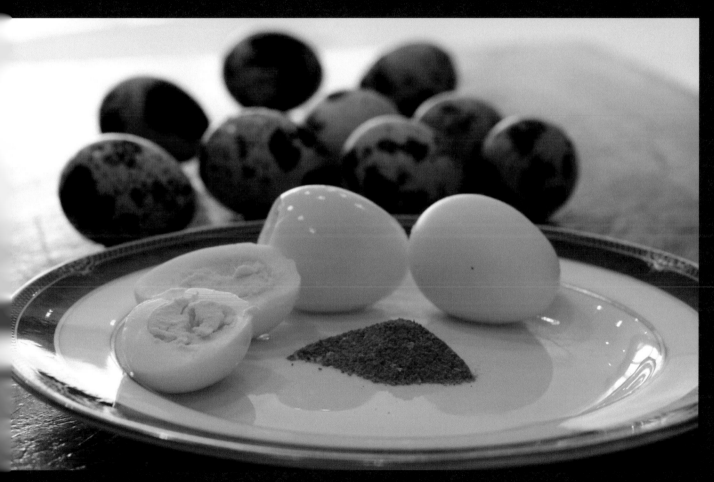

Hard boil the eggs for 4 mins, cool quickly and peel. To make peeling easier roll eggs on worktop first to break shell. Serve with a dipping bowl or plate of celery salt.

Ingredients:
50g butter, 1 tbsp olive oil, 1kg onion, 1 tsp sugar, 4 garlic cloves, 2 tbsp plain flour, 250ml dry white wine
1.2l strongly-flavoured beef stock, French bread, 140g Gruyère.

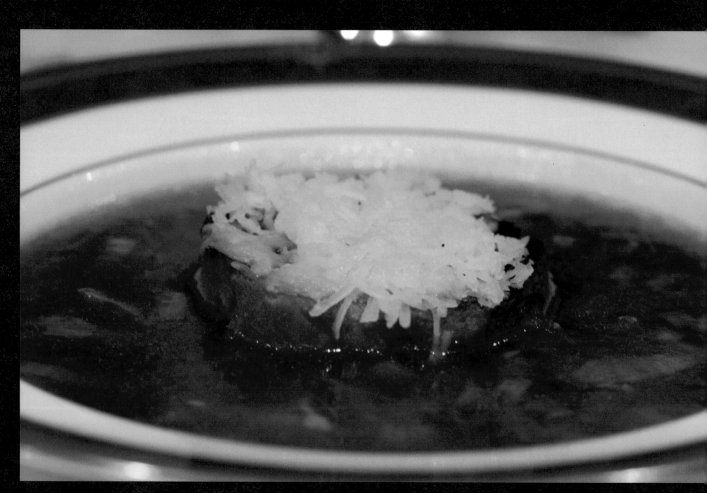

Melt the butter with the oil in a large pan. Add the onions and fry with the lid on for 15 mins until soft. Sprinkle in the sugar and
cook for 20 mins more, stirring frequently, until caramelised. Then add the garlic and sprinkle in the flour and stir well. Increase
the heat and keep stirring as you gradually add the wine and the beef stock. Cover and simmer for 20 mins. Turn on the grill,
toast the french bread and grill with plenty of cheese on top. Serves 4.

Bangers, mash and beans

ngredients:
3 sausages, 1/2 tin of Heinz baked beans, 2 potatoes, 1/4 glass milk, salt, pepper, a chunk of butter, 2 tspn wholegrain mustard.

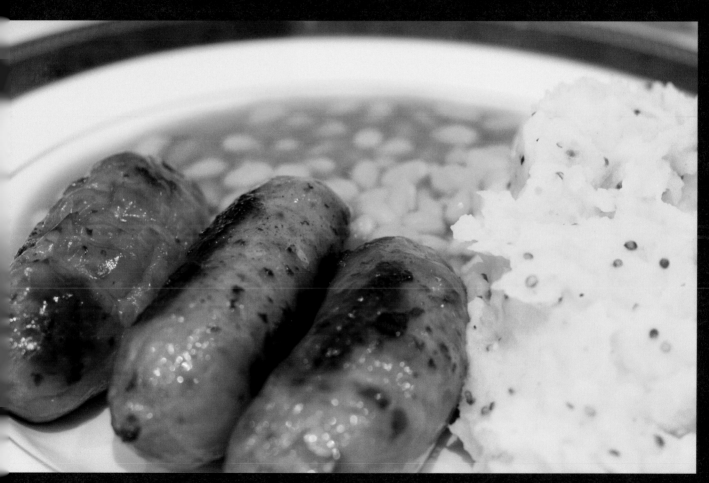

Place the sausages in the oven 200C for 20 mins. Peal and boil the potatoes until soft, drain and add the butter, milk, plenty of salt and pepper and the wholegrain mustard and mash until creamy and smooth; you may need to add more butter and milk. Warm up some Heinz baked beans and serve. Serves 1.

Ingredients:
4 eggs, a generous splash of milk, a chunk of butter, salt, pepper, smoked salmon and chives for garnish.

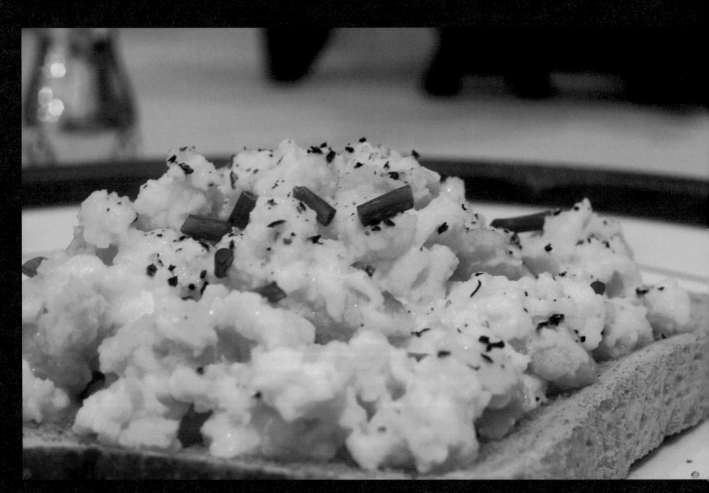

Beat the eggs in a bowl with a pinch of salt and some black peeper. Melt some butter in a pan and add the eggs and som
milk, stir with a wooden spoon until the eggs have silky and smooth look and just start to "scramble". Remove from the hea
(the eggs will continue to cook) and add the smoked salmon (cut into 1 inch pieces), beat until the eggs are to the consistenc
that you like. Serve with some chopped chives and more black pepper on toast. Serves 2.

Double eggs benedict

Ingredients:
2 eggs, 1 tbsp white wine vinegar, 1 english muffin, ham, chives.

Hollandaise sauce:
1 tsp lemon juice, 1 tsp white wine vinegar, 2 egg yolks, 65g butter.

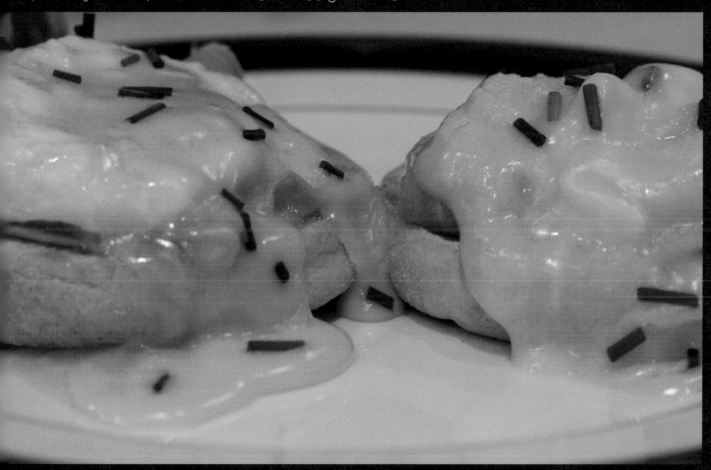

First make the hollandaise sauce. Add the lemon juice, eggs, and vinegar and whisk until light and frothy. Place the bowl over a pan of simmering water adding the butter bit by bit until the mixture thickens, leave to one side. To poach the eggs add some vinegar to the boiling water, stir to create a whirlpool and then add the eggs and lower the heat slightly. Cook for 4 mins and remove. Cut the muffins in half, lightly toast and butter the muffins, add some ham, top with an egg, cover with hollandaise and garnish with chopped chives. Just like breakfast at St James' Palace. Serves 1.

Ingredients:
25g butter, 1 onion, 2 tsp turmeric, 2 tsp garam masala, 200g basmati rice, 500ml chicken stock, 250 smoked haddock fillet, 2 eggs, 1 lemon, salt and pepper.

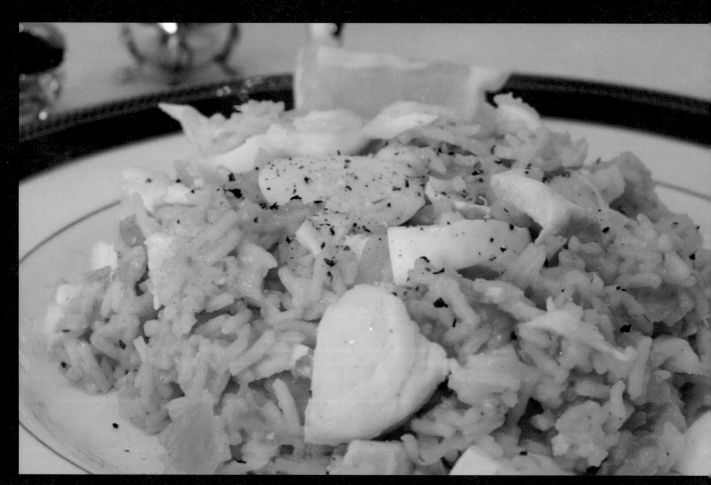

Melt the butter in a saucepan, add the onions and cook for 5 mins. Add the tumeric and garam masala and cook for 1 min. Sti in the rice and then add the stock and half tsp of salt and bring to the boil. Cover with a lid and simmer for 12 mins. Boil some water and add the haddock and simmer for 4 mins. Hard boil the eggs. Flake the fish and then add the Haddock along with the chopped eggs to the rice and heat for a further 2 mins. Serve and garnish with black pepper (parsley and lemon optional Serves 4.

ngredients:
Leg of lamb or whole chicken or beef, or pork, birds eye frozen peas, 7 sspns vegetable oil, 6 potatoes, 8 carrots, 4 parsnips, 2 onions, mixed herbs, salt, pepper, gravy (see week 42)

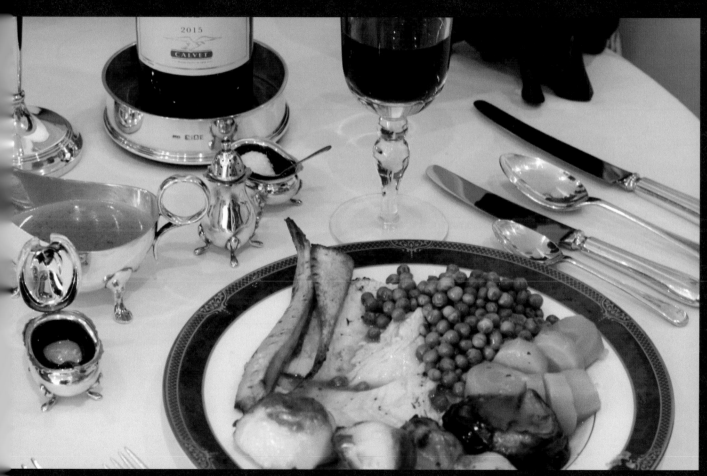

Much easier than you would think! Peel the potatoes, carrots and parsnips and cut the onions in half (discarding the outer skin). Cut the potatoes into quarters, cut the parsnips (in half length ways) and chop the carrots. Pour the vegetable oil into a baking tray, add the Sunday joint - chicken (lightly covered with mixed herbs) or the leg of lamb (lightly covered with rosemary and garlic) or the beef or pork. Add the potatoes, parsnips and onion and cover everything with the vegetable oil (if using pork do not cover the topside with oil if you want crackling) add salt and pepper. Place in a preheated oven 180C for approx 1 1/2hrs (check the packaging on the meat for the correct cooking time). Halfway through the cooking remove the baking tray and turn the potatoes over spooning the hot oil over them. Boil some peas and the carrots in separate saucepans, drain, allow meat to "rest" for 10 mins whilst making the gravy. For gravy see week 42. Serves 4.

Ingredients:
For the soufflés: butter for greasing, 50g caster sugar, plus 2 tbsp extra, 175g dark chocolate (70% cocoa), 2 tbsp double cream, 4 egg yolks, 5 egg whites.
For the hot chocolate sauce: 100ml single cream, 20g caster sugar, 75g dark chocolate (70% cocoa), 20g butter.

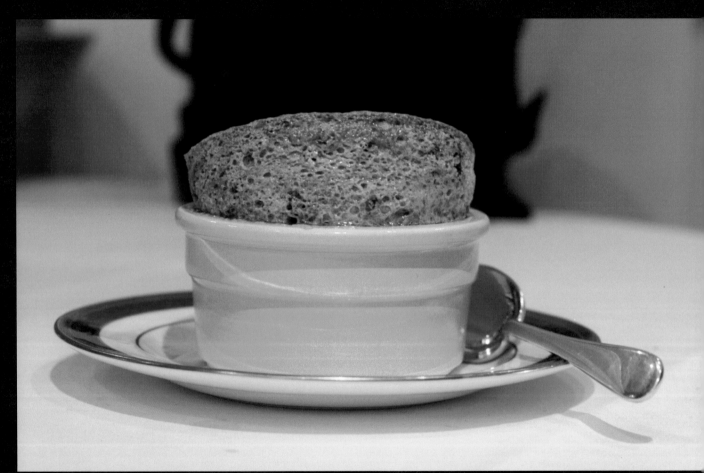

Heat oven to 220C, place a baking tray on the top shelf. For the sauce, heat the cream and sugar until boiling. Remove from the heat, stir in the chocolate and butter until melted, leave to one side. Brush the ramekins with butter, sprinkle with the 2 tbsp caster sugar, then tip out any excess. For the soufflé melt the chocolate and cream in a bowl over a pan of simmering water, cool, then mix in the egg yolks. Whisk the egg whites until they hold their shape, then add the sugar, 1 tbsp at a time whisking back to the same consistency. Mix a spoonful into the chocolate, then gently fold in the rest. Fill the ramekins, wipe the rims clean and run your thumb around the edges. Turn oven down to 200C, place the ramekins onto the baking tray, then bake for 10 mins. Once the soufflés are ready, scoop a small hole from their tops, then pour in the hot chocolate sauce. Serve immediately. Serves 4.

ngredients:
1 bag of mixed salad, 1 tin of tuna, 1/2 onion, 1 spring onion, 3 tomatoes, 1 pepper, cucumber, beetroot, salt and pepper.

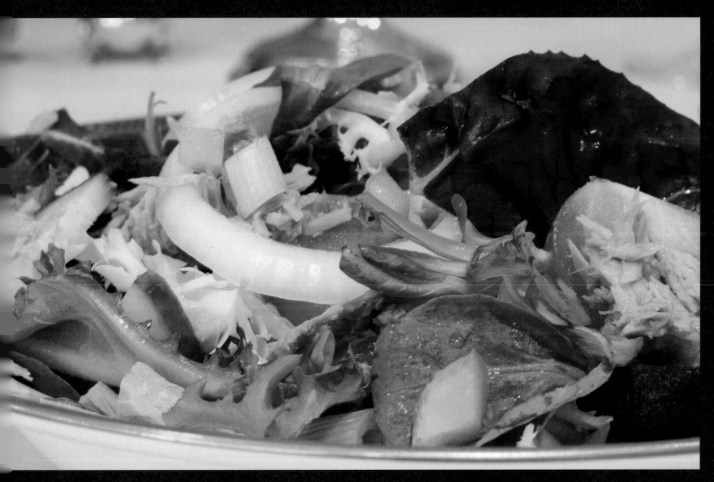

Chop the tomatoes, cucumber, beetroot and spring onion and pepper, add the onion rings, tuna and salad. Mix well in a salad bowl and add some salt and pepper. Salad dressing and mayonnaise optional. Serves 2.

Ingredients:
1 French Baggette, sliced emmental cheese, sliced saucisson.

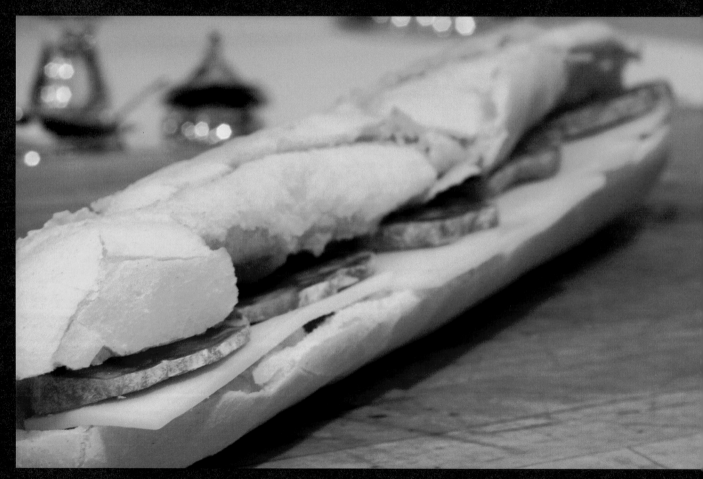

Fill a baggette with a filling of your choice. The ideal packed lunch. This one is called "Le dejourner de parapentes" whic
traditionally consists of a visit to the local French boulangerie first thing to collect a freshly made baggette which is then fille
with emmental and saucisson to be enjoyed later for lunch on top of a hill in the Alps. Serves 1.

"Athi river"
French Dressing

Ingredients:
7 tbspns olive oil, 3 tbspns wine vinegar, 1 tspn whole grain mustard, pinch of sugar, salt and pepper, 1/4 clove of garlic.

Crush and finely chop the garlic, add all of the ingredients to a sealable jar, don't forget to put the lid on! Shake vigorously. Shake again before pouring over the salad. This one is named after the Athi river (Nairobi), as the contents look remarkably similar. You will often hear people at the table in that part of the world asking for the "Athi river".

Ingredients:
Oil and cooking fat from the Sunday roast, water from the boiled vegetables, red or white wine, red curren
jelly, salt, pepper, vegetable/beef cube, flour.

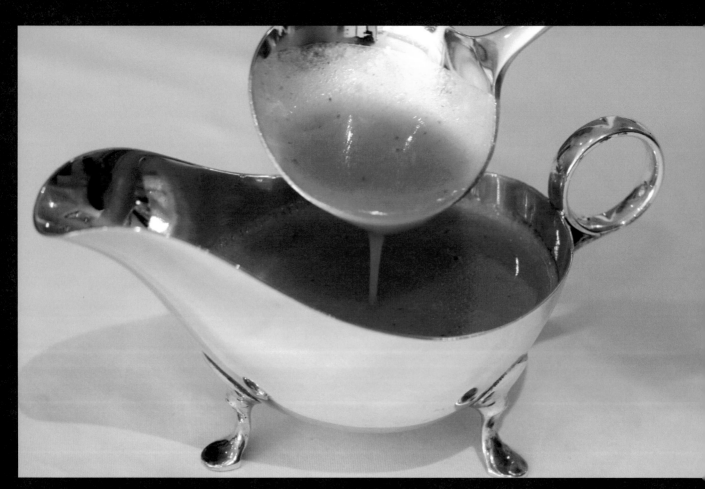

There are no exact measurements, trial and error will only improve on the taste of the gravy, the more you make it the better
becomes. Remove the Sunday joint, potatoes, parsnips, onion and any vegetables from the baking tray and place the tray o
a hot hob. Add a half handful of flour, some water from all of the boiled vegetables, a slug of wine, salt, pepper and a spoo
of redcurrant jelly along with a vegetable/beef cube. Allow to boil stirring throughout. Taste and add a bit more of the abov
ingredients until you have nailed the flavour/consistency.

Ingredients:
1 salmon fillet steak, 6 asparagus, 3 new potatoes, butter, oil, salt, pepper, lemon, chives and parsley.

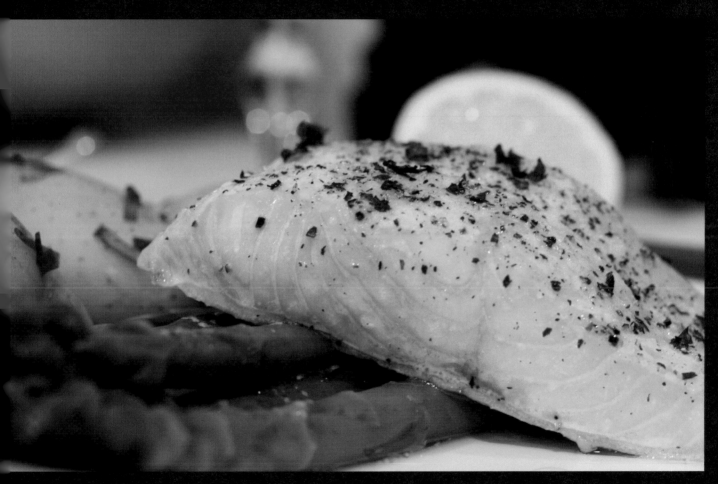

Lay some tin foil on a baking tray, place the salmon onto the tin foil and cover lightly with oil, salt and pepper. Cook in a pre heated oven 180C for 6 - 8 mins, depending on size of the fish. Boil some new potatoes with some chopped chives in the water, boil the asparagus, drain and serve. Pour some melted butter over the asparagus, some parsley, pepper and lemon over the salmon steak. Serves 1.

Ingredients:
Bolognese sauce - 1/2 onion, tsp oil, 1 garlic clove, 500g mince beef, 2 tsp mixed herbs, 1 beef cube, 1 ti
chopped tomatoes, salt, pepper.
White sauce - 40g butter, 30g plain flour, 425ml milk.
100g cheddar cheese, 150g ready to cook dried lasagne pasta.

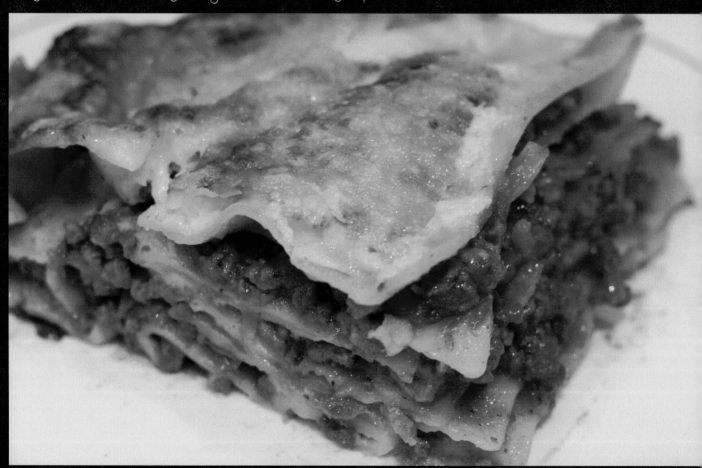

White sauce - add all three ingredients into a saucepan and warm and stir until thick. Bolognese sauce - chop and fry th
onion and garlic with oil until soft then add the beef. Once browned add the herbs, the stock cube, a little salt and pepper an
tomatoes and simmer for 10 mins. Make the Lasagne in layers starting with the bolognese sauce, then white sauce followed
by the pasta. Repeat the layers. To finish add the grated cheese on top. Place in a preheated oven 180C for 40 mins. Serve
with peas or salad. Serves 4.

ingredients:
100g butter, 200g plain flour, 100g soft brown sugar, 40g porridge oats, 1kg cooking apples, 2 tbspn caster sugar, 200g blackberry's.

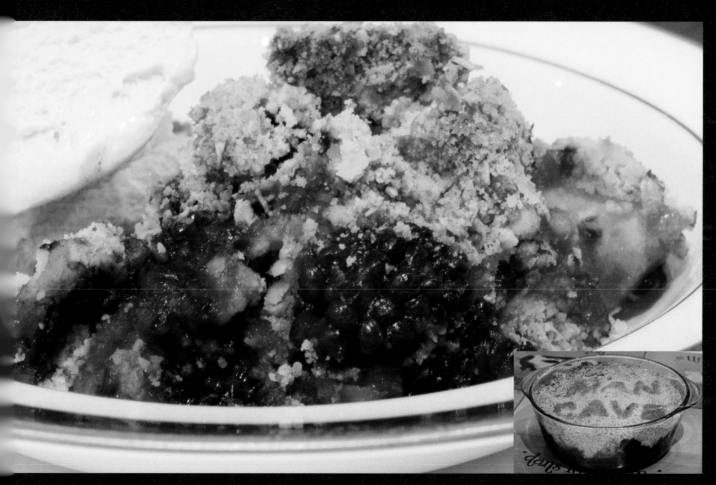

Peel and core the apples and cut into bite size chunks. Place the apples and blackberry's into a deep dish and sprinkle over the caster sugar. Mix the butter and flour together with your fingers until crumbly then mix in the brown sugar and oats. Pour the crumble on top of the apple and blackberry and place in a pre heated oven 180C for 40 mins. Serve with cream or custard or vanilla ice cream. Serves 4.

Ingredients:
400g white fish fillet, 200g smoked haddock fillet, 200g salmon fillets, handful of pre cooked prawns, 600ml
milk, 4 eggs, 100g butter, 50g plain flour, 1kg potato, salt, pepper, parsley and a little grated cheddar cheese

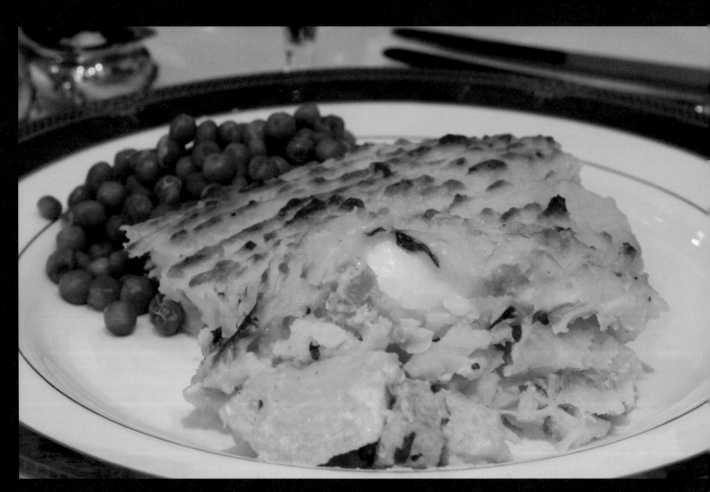

Put the fish in a frying pan and cover with 500ml milk. Bring the milk to the boil and then reduce the heat and simmer for 8
mins. Lift the fish onto a plate and strain the milk into a jug to cool. Flake the fish into large pieces in the baking dish and add
the prawns. Hard-boil the eggs, slice into quarters and arrange on top of the fish, then cover with chopped parsley. To make
the sauce: Melt half the butter in a pan, stir in the flour and cook for 1 min on medium heat. Stir in the cold poaching milk until
you have a smooth sauce. Then bring to the boil and cook for 5 mins, stirring continually, then pour over the fish. To make the
topping: Peel and boil the potatoes for 20 mins. Drain, season and mash with the remaining butter and milk. Cover the fish
with the mashed potato and then lightly cover with grated cheese then bake for 30 mins in a pre-heated oven at 200C. Bes
served with peas and tommy K! Serves 6.

ingredients:
Bread rolls - see week 24 (omitting brushing them with salted water) or buy ready made rolls, 500g mince beef, 1 onion, 1/2 lettuce, 6 slices of cheese, 2 tomatoes, 12 gherkins, 6 rashers of bacon, 1 tbspn oil, tommy K and salad cream.

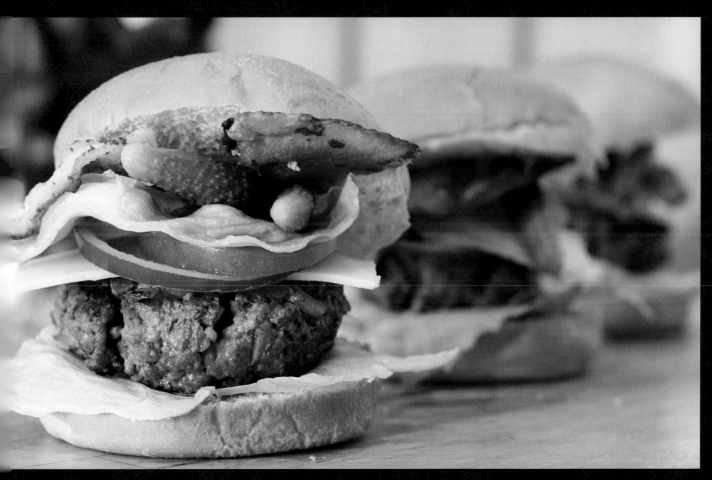

Chop half the onion into fine pieces and add to the mince. Cut the other half into rings. Roll the mince into hand sized balls and gently flatten into burger shapes. Fry the burgers and bacon with some oil until cooked to your liking. Cut the rolls in half, layer with lettuce, burger, cheese, onion rings, more lettuce, gherkins, bacon and top with tommy K and salad cream and then place the top of the bun and serve. Serves 6.

Ingredients:
6 egg yolks, 300 ml double cream, 1 tsp vanilla extract, 75g sugar, plus 3 tbsp sugar (for grilling).

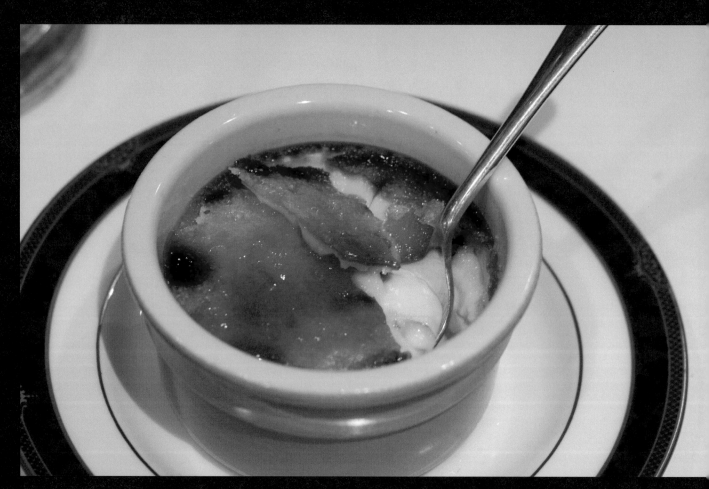

For best results make these a day before. Pre heat the oven to 140C. Put the cream into a pan and add the vanilla extrac
and heat and as soon as it starts to boil remove and stir in the whisked eggs and sugar. Fill the ramekins three quarters ful
and place them onto a baking tray adding boiling water half way up the side of the ramekins (bain marie). Cook for 30 mins
Remove the ramekins from the water and place on the side to cool, once cooled place in the fridge. An hour or so before you
are going to serve them sprinkle ½ tbspn of sugar on top of each ramekin. Place them under the grill for 3 mins for the suga
to change colour and caramelise. Allow to cool in the fridge before serving. Serves 6.

ngredients:

Calvados, Armagnac, Whisky (A good malt - not everyone likes to mix theirs), Port, Cognac, Kummel, Sherry, Pernod, Gin, home made Sloe Gin and Vodka. Good quality vodka should be kept in the freezer as t should be drunk neat, never mixed, and very cold. Ice bucket with tongs and lemon chopping board with nife.

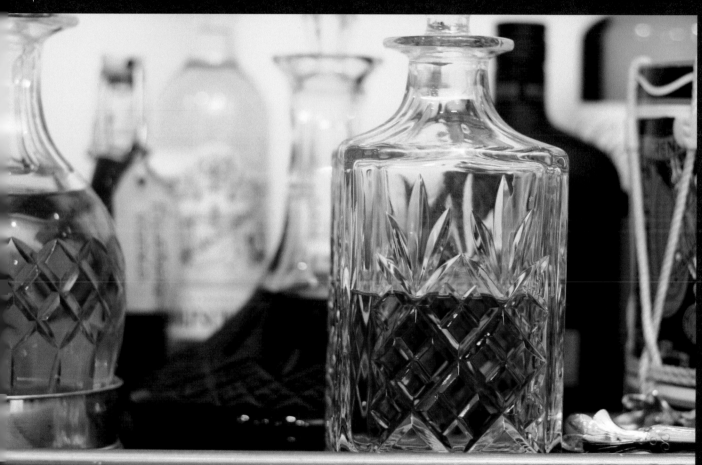

A well stocked drinks cabinet or tray is essential in order that you can offer your visitors their favourite tipple. Ice should always be well stocked in the freezer, along with a good bottle of vodka. A couple of bottles of white wine along with some tonic water, beer and coke should be kept in the fridge along with a lemon and lime. Having a bottle or two of red, or wine box, on stand by is also a good idea. In addition a bottle of champagne should always be in the fridge, you never know when you will need t to celebrate something.

Ingredients:
Calvados, Armagnac, Cognac etc.

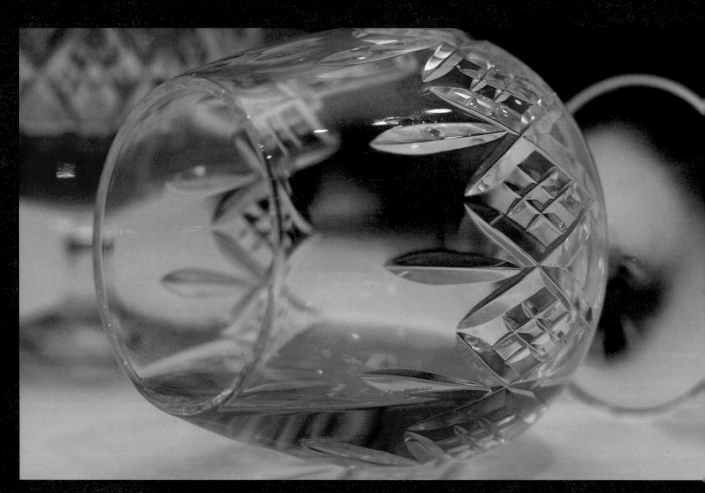

To ensure you have served the correct amount in the crystal glass, the liquid should be bulging over the edge but not spilling, when the glass is on its side. With practice you will be able to pour the correct measure every time.

ngredients:
Coffee
milk and sugar optional.

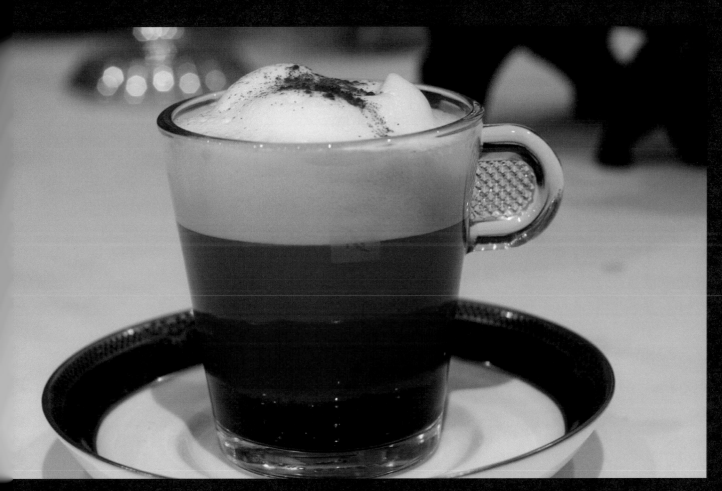

Every day should start with a decent cup of coffee; after entertaining and eating with friends a coffee is the norm. Do not skimp and serve instant coffee, invest in a decent machine, you will not regret it - this one also comes with a milk warmer and can also froth milk for cappuccinos. Try a tiny sprinkle of cinnamon in your cappuccino - finishes it of perfectly. Many thanks to my dear friends for giving it to me as a "Man Cave moving in present" - love it.

Ingredients:
Any meat, fish, vegetables of your choosing, marinating first optional (but well worth the prep time if you have it).

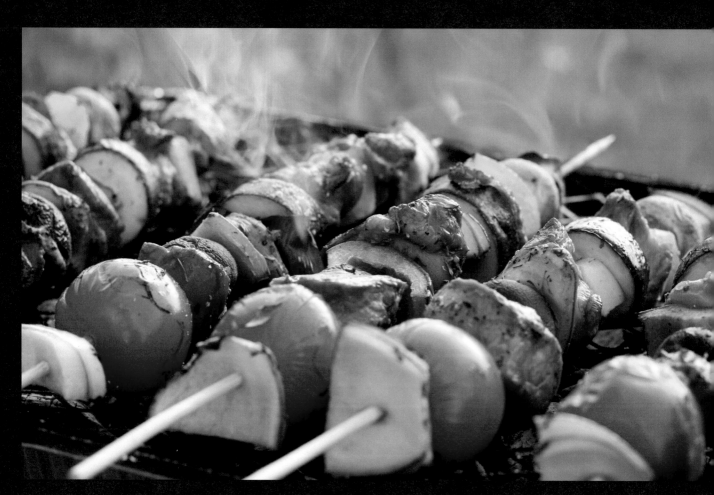

The barbecue - the ultimate in the Man Cave repertoire. Fire, meat and beer, what isn't there to love about a BBQ. Man has been poisoning each other by cooking over fire since the beginning of time, so remember to wait for the flames to die down and the charcoal is white hot (grey and glowing) before cooking; if your meat is black and burnt on the outside it does not mean it is cooked on the inside!

Remember every recipe can be handled by a Numpty!

Good Luck

Lightning Source UK Ltd.
Milton Keynes UK
UKRC02n0844171117
312759UK00001B/4